Tranquility Coloring In Bloom

Jennifer Copp

All rights reserved. This book or parts thereof may not be reproduced in any form, stored in any retrieval system, or transmitted in any form by any means, electronic mechanical, photocopy, or otherwise, without prior written permission of the author.

2017 Jennifer Copp. All rights reserved.

Enjoy coloring the tranquil pages of my first Grayscale coloring book. My first of many books are photographs "In Bloom" taken by me. An avid photographer, I aspire to spread the beauty of the world through pictures and colors. By providing you with the images in Grayscale, you can express your artistic style through your imagination.

What is Grayscale you ask? Other than being addictive, relaxing and having the ability to make you look like a VERY skilled artist; it is simply, black and white images with many shades of gray. At first glance you think "no way….that looks too hard". I assure you it is not. You simply color over, with the side of your pencil, the white and gray parts and you have a gorgeous colored image that looks like a painting.

In addition to my book, all you need are some of your favorite colored pencils (I prefer the soft ones) and some cotton swabs to run gently over the page to eliminate any pencil lines. The key to a soft look is a light touch and increase layers to deepen the colors. Pressing too hard will cause you to lose the photo underneath. You can also experiment with gel pens, my personal favorite is the Yummy Scented, and eye shadow for the background (apply with the cotton balls or swabs).

I hope you enjoy coloring these pages as much as I enjoyed capturing the photo.

Visit the Tranquility Photography group on Facebook to share your pictures!

Enjoy!
Jennifer

I dedicate this book to my father who inspired me to pick up a camera, my mother who has always supported and encouraged me while being my biggest fan and most importantly my husband and daughter who have always pulled over to get that perfect shot.

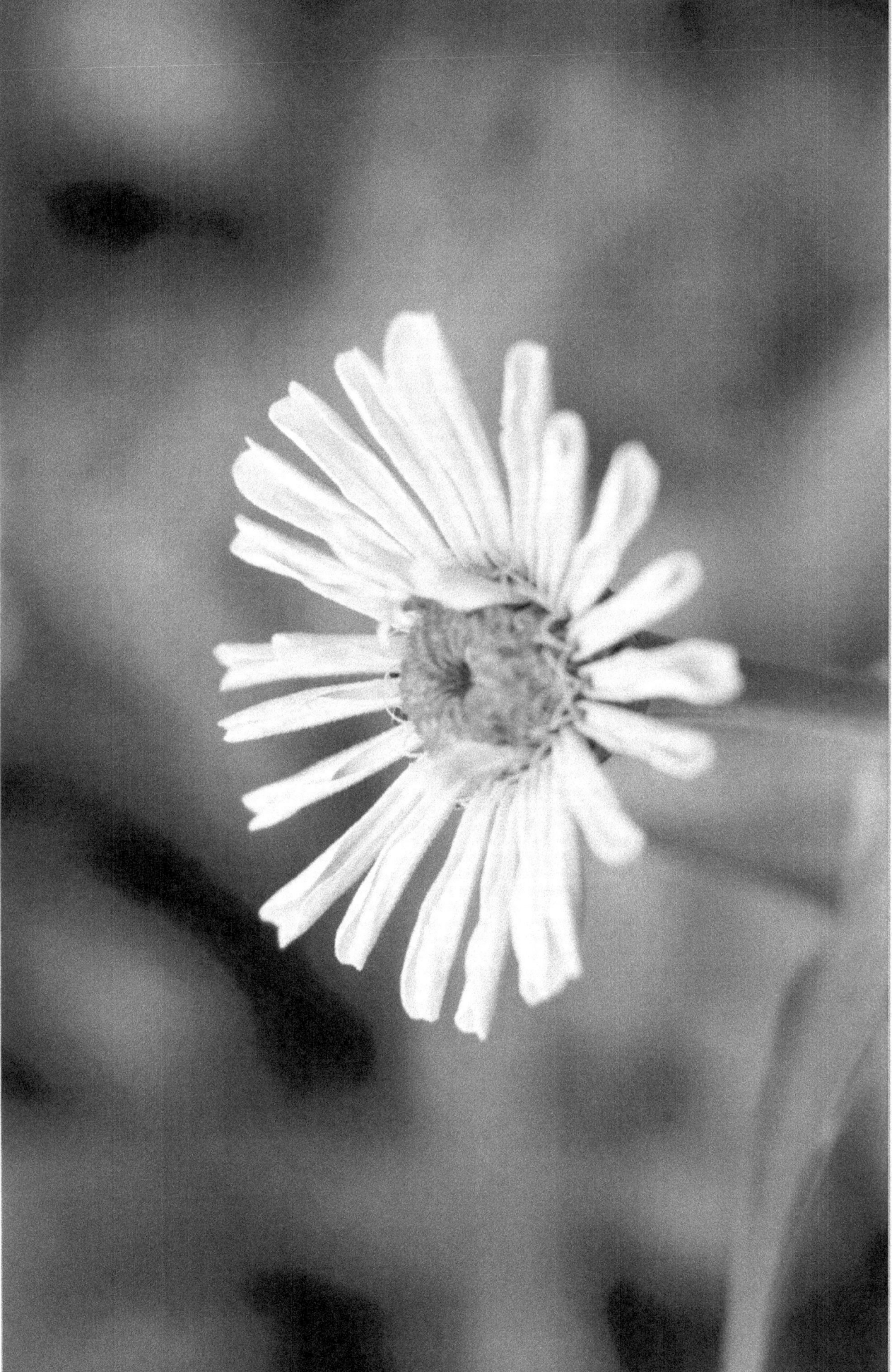

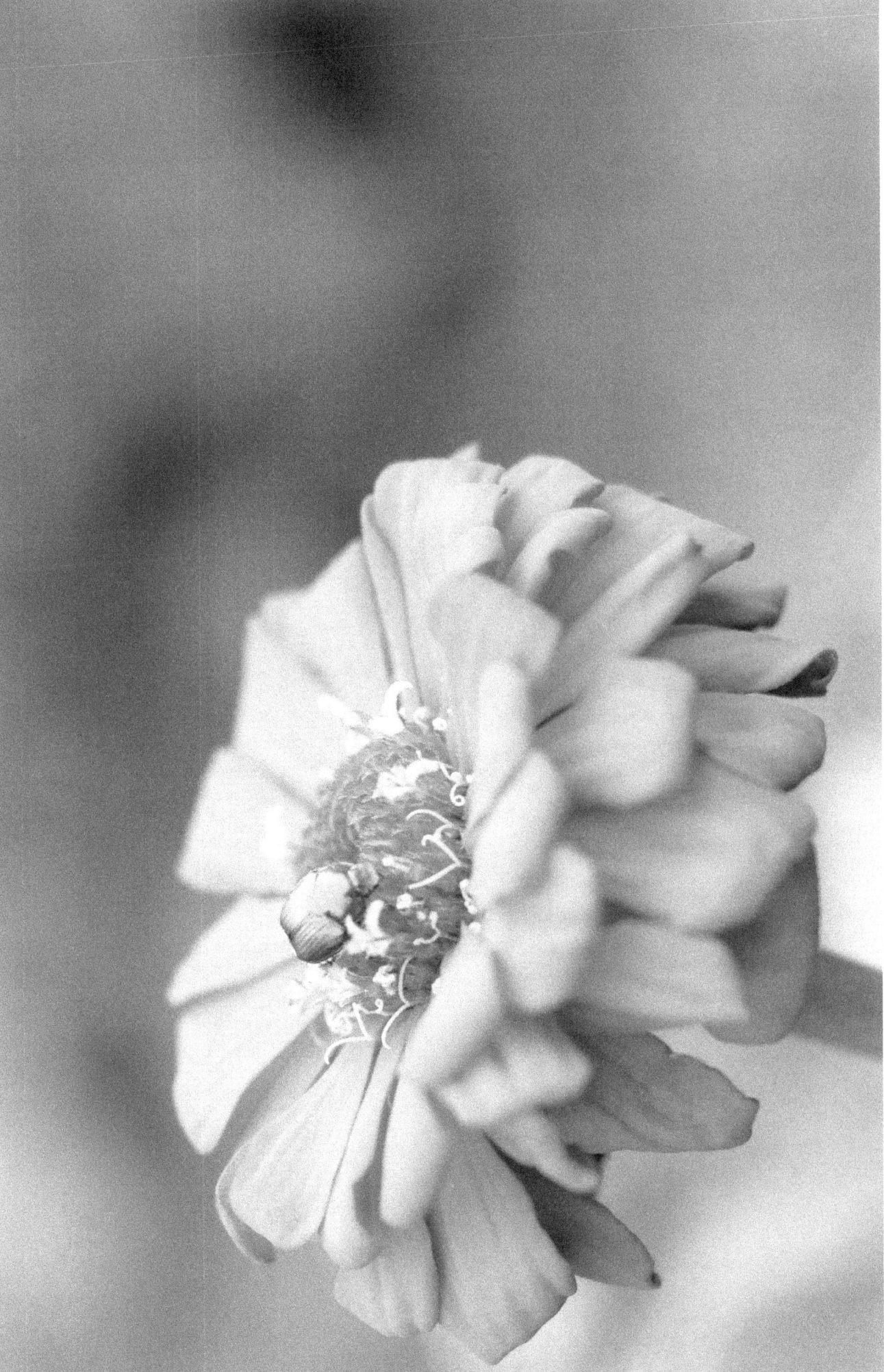

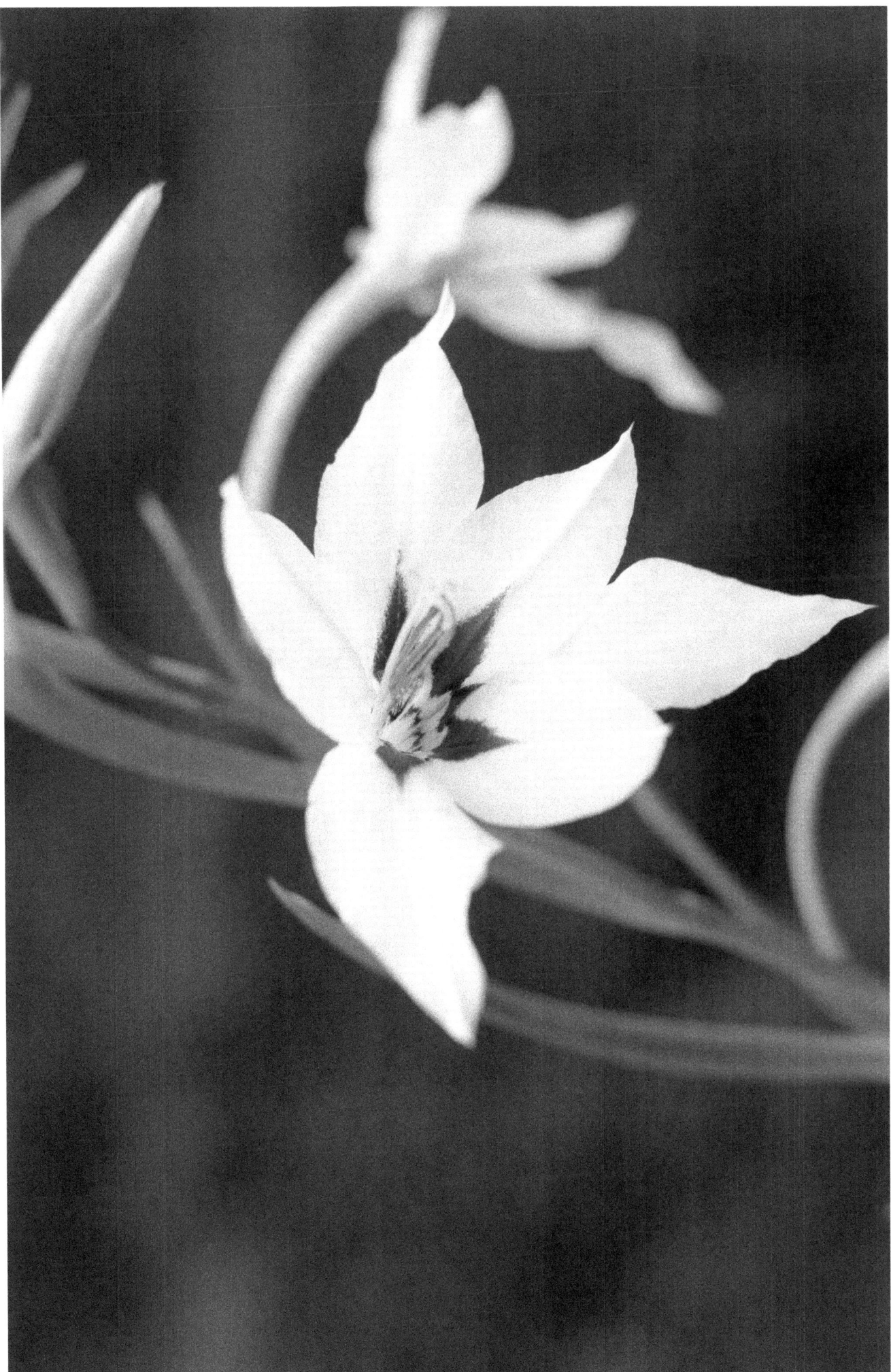

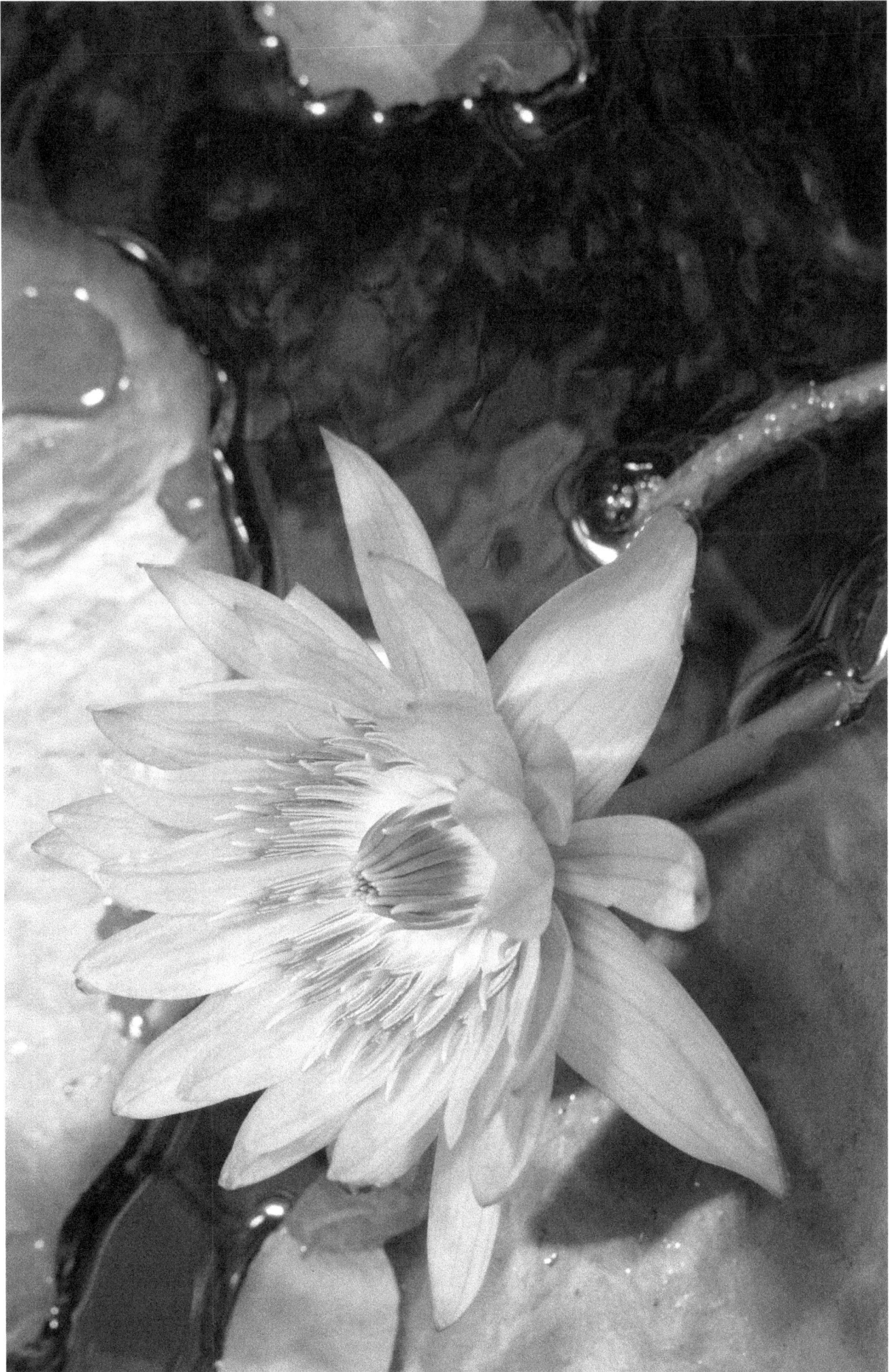

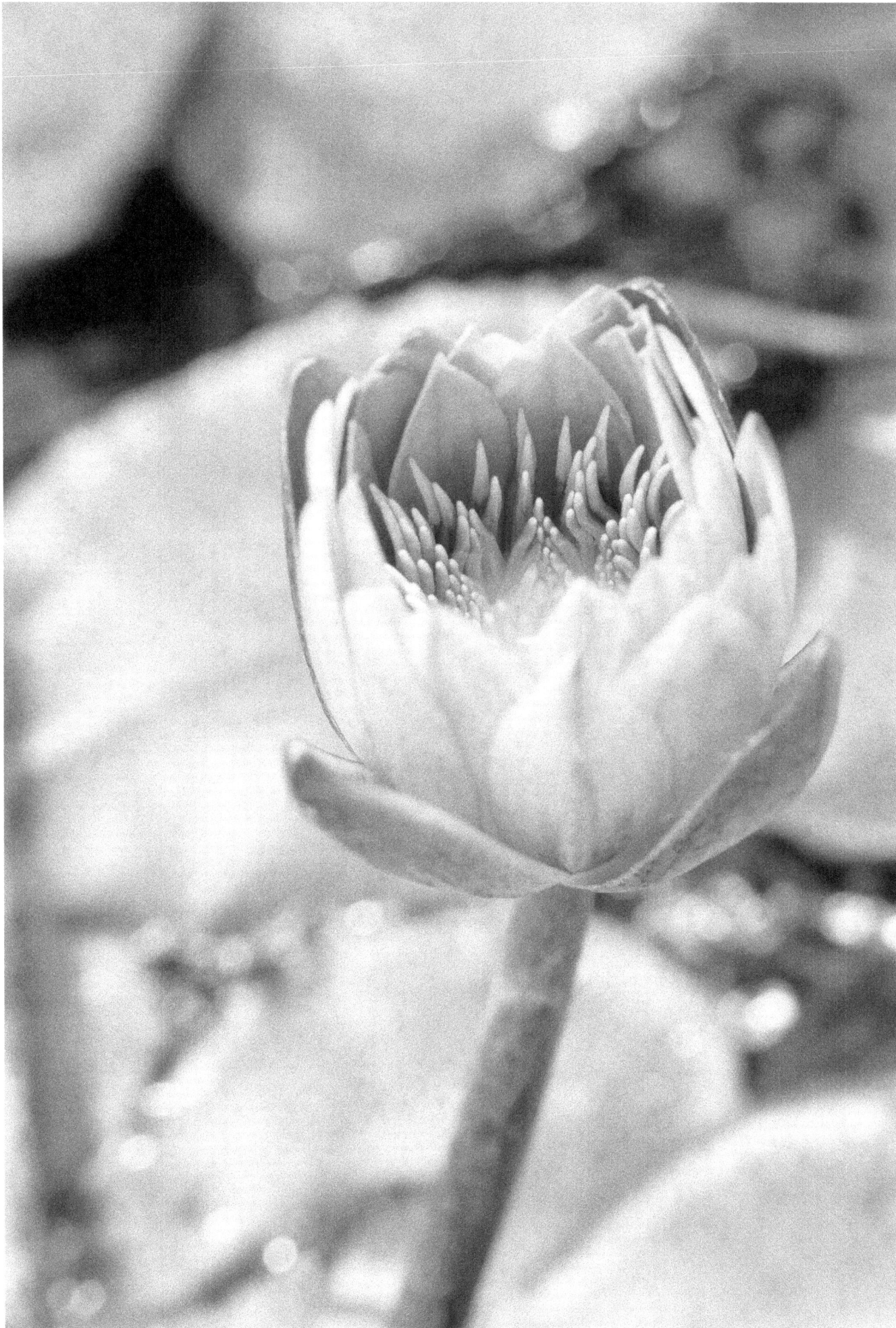

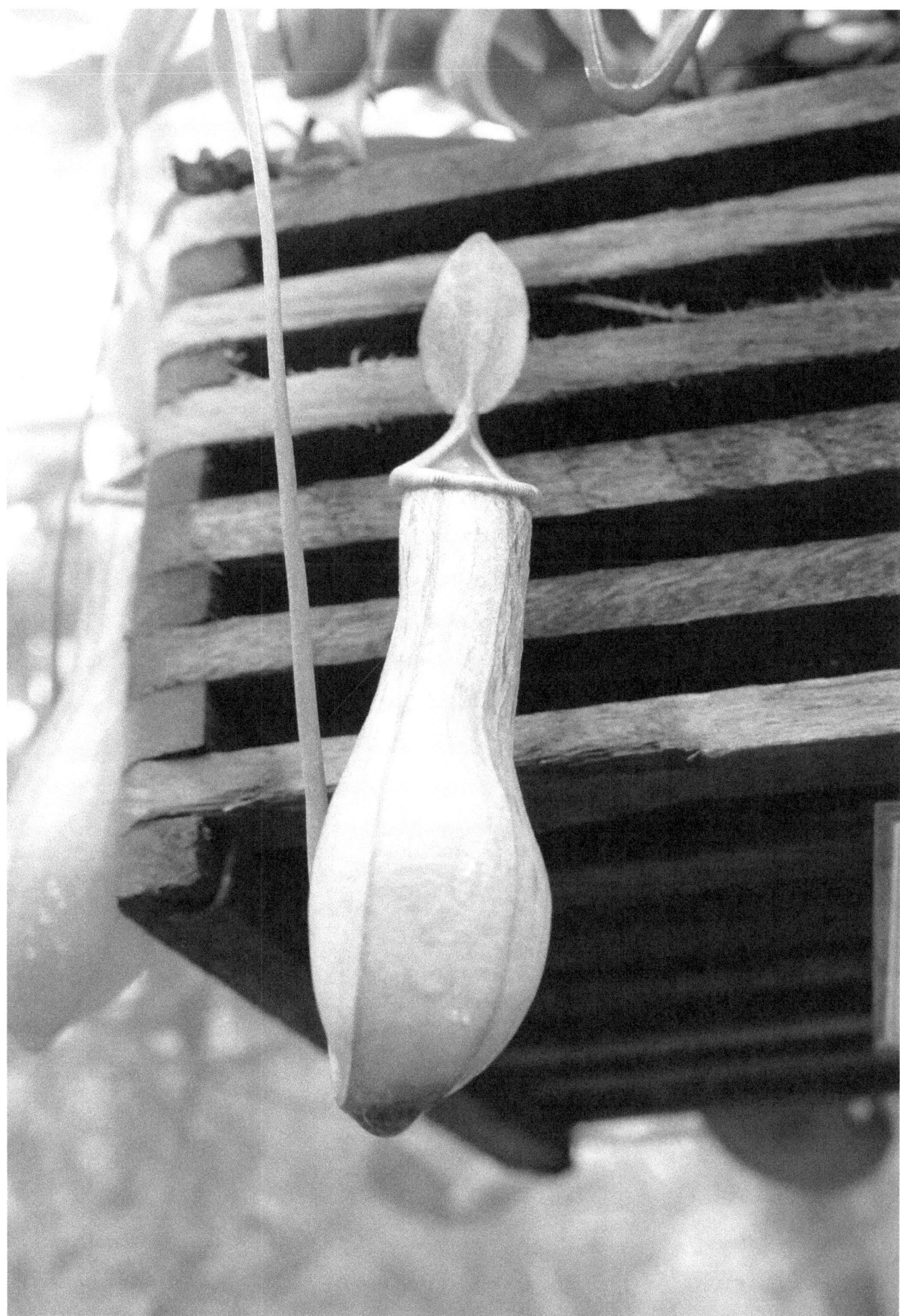

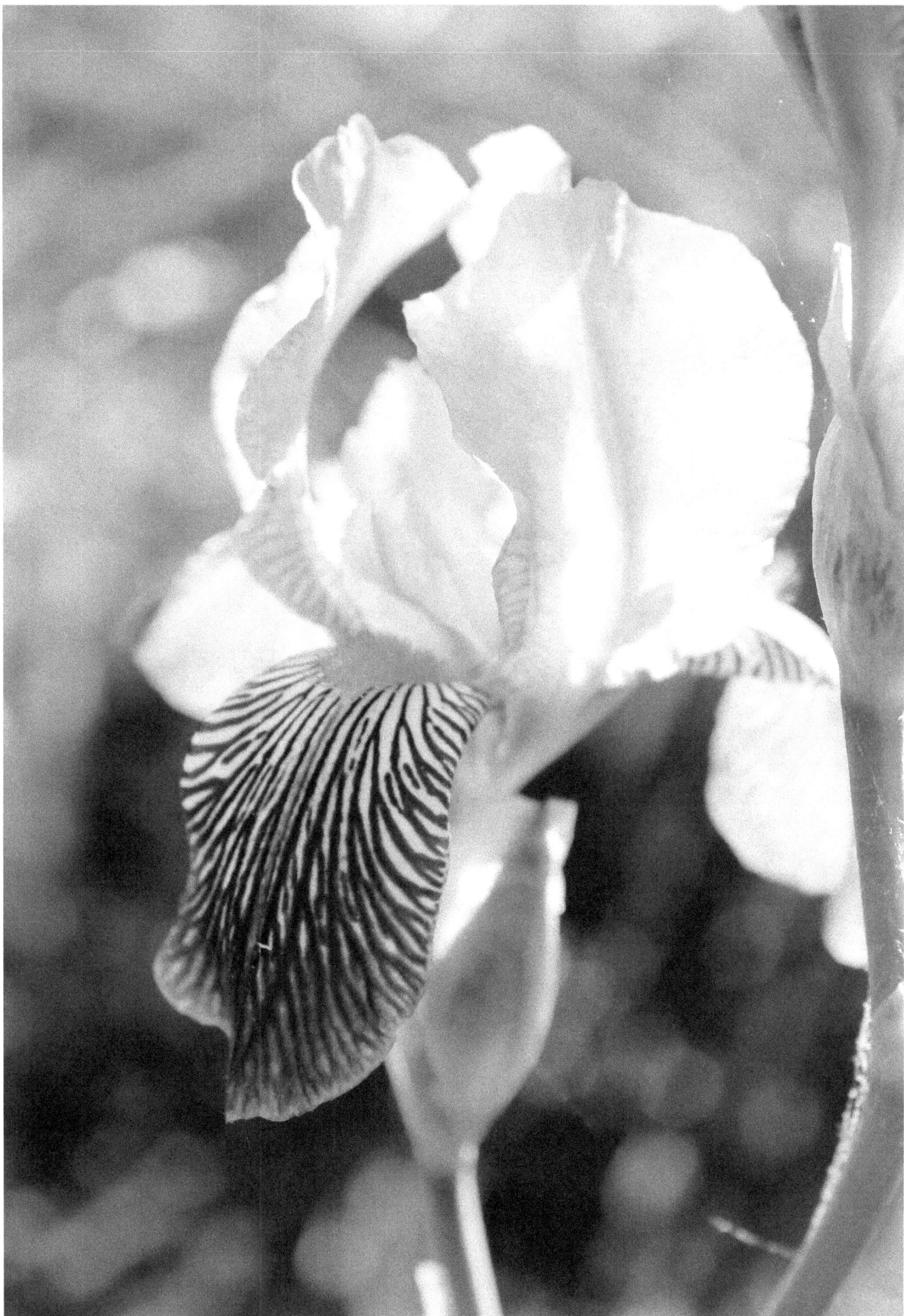

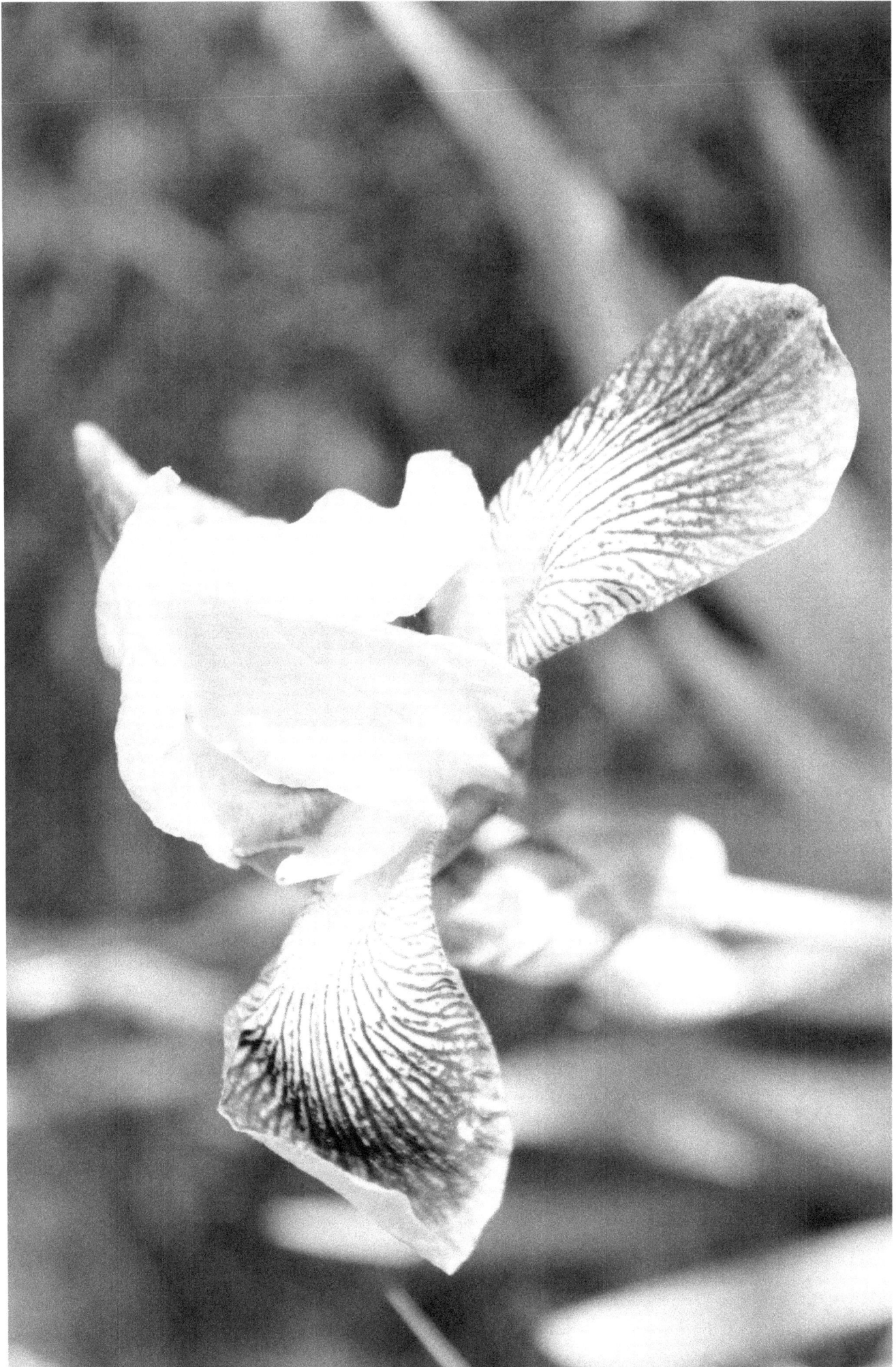

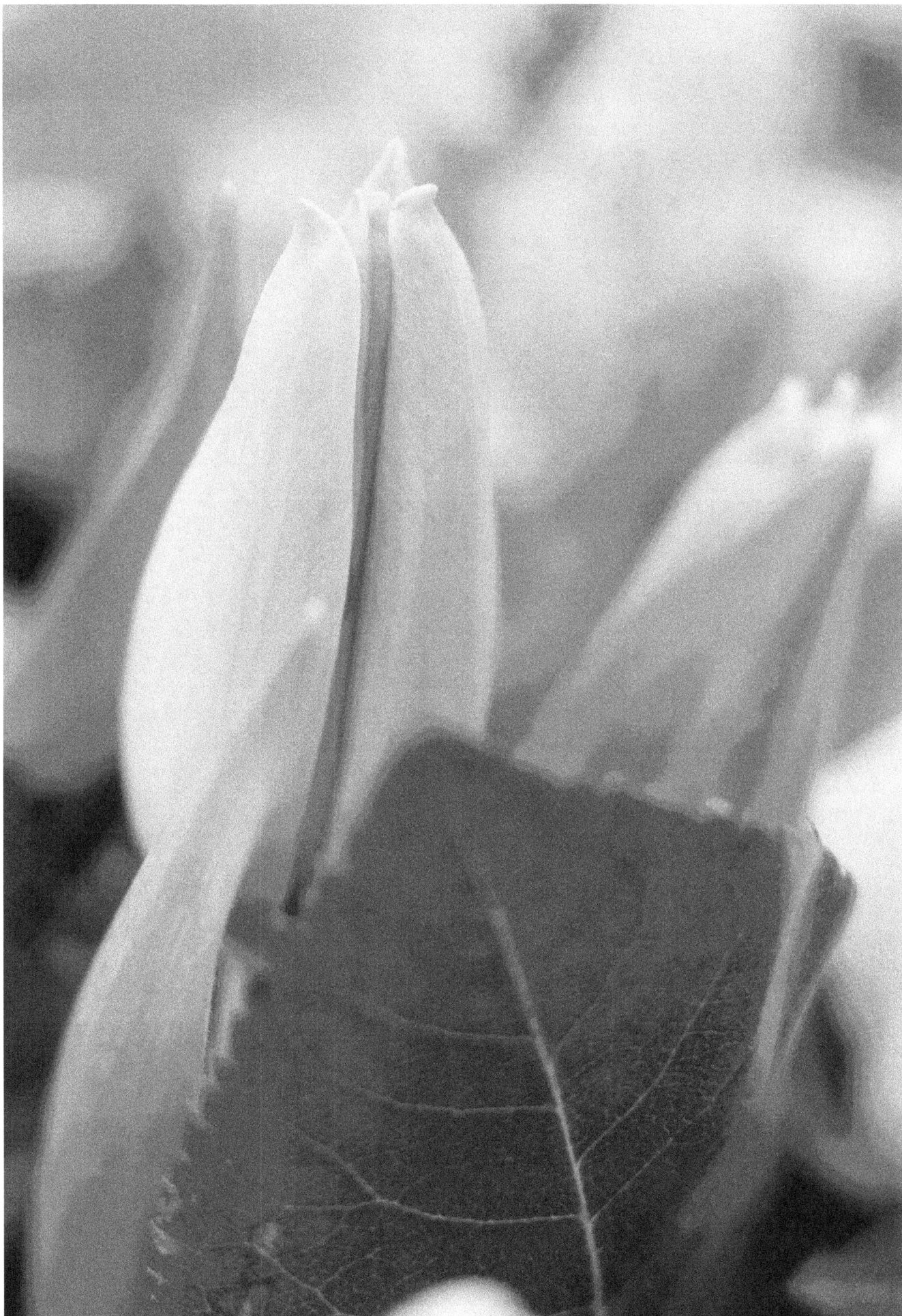

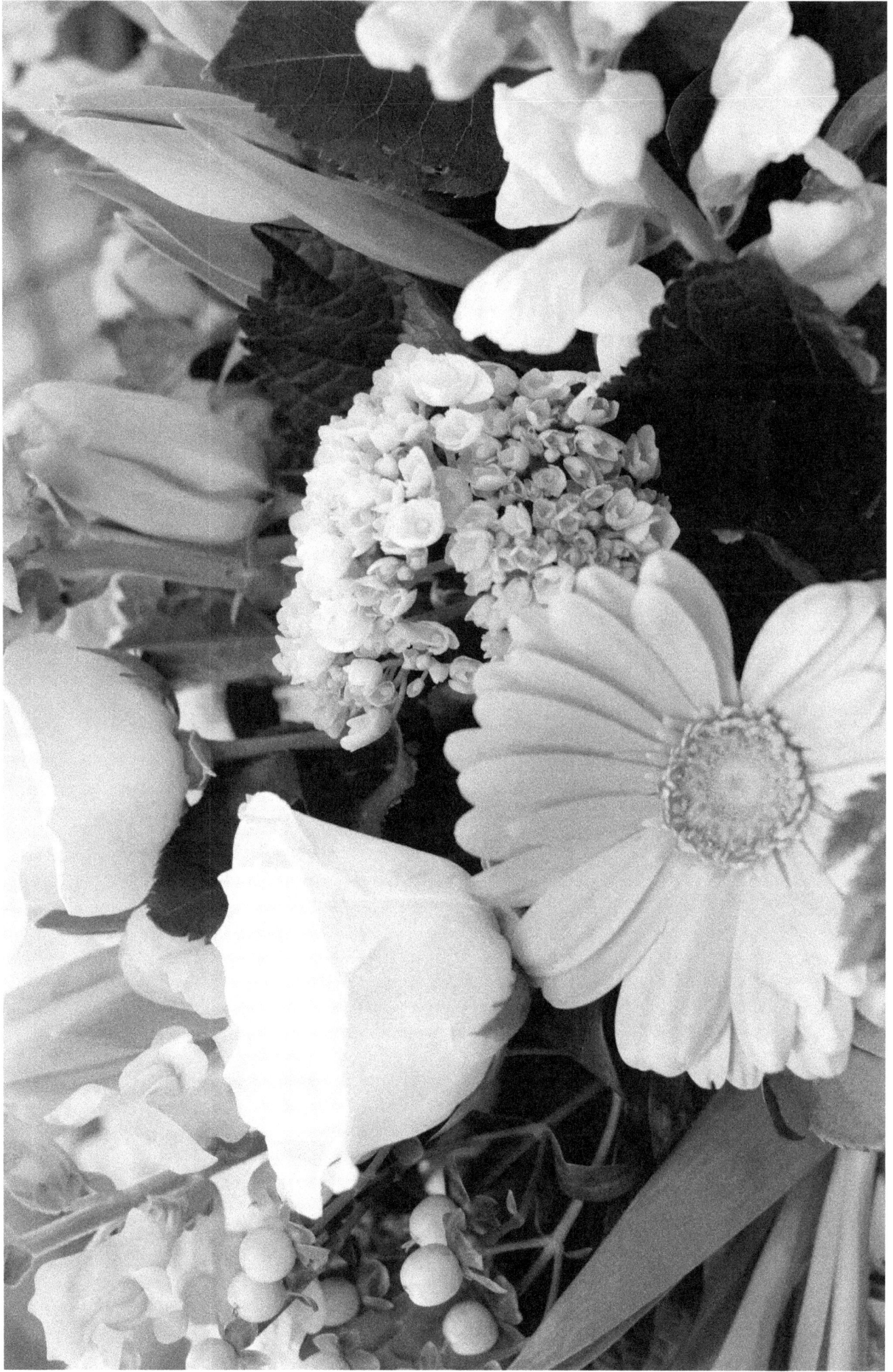

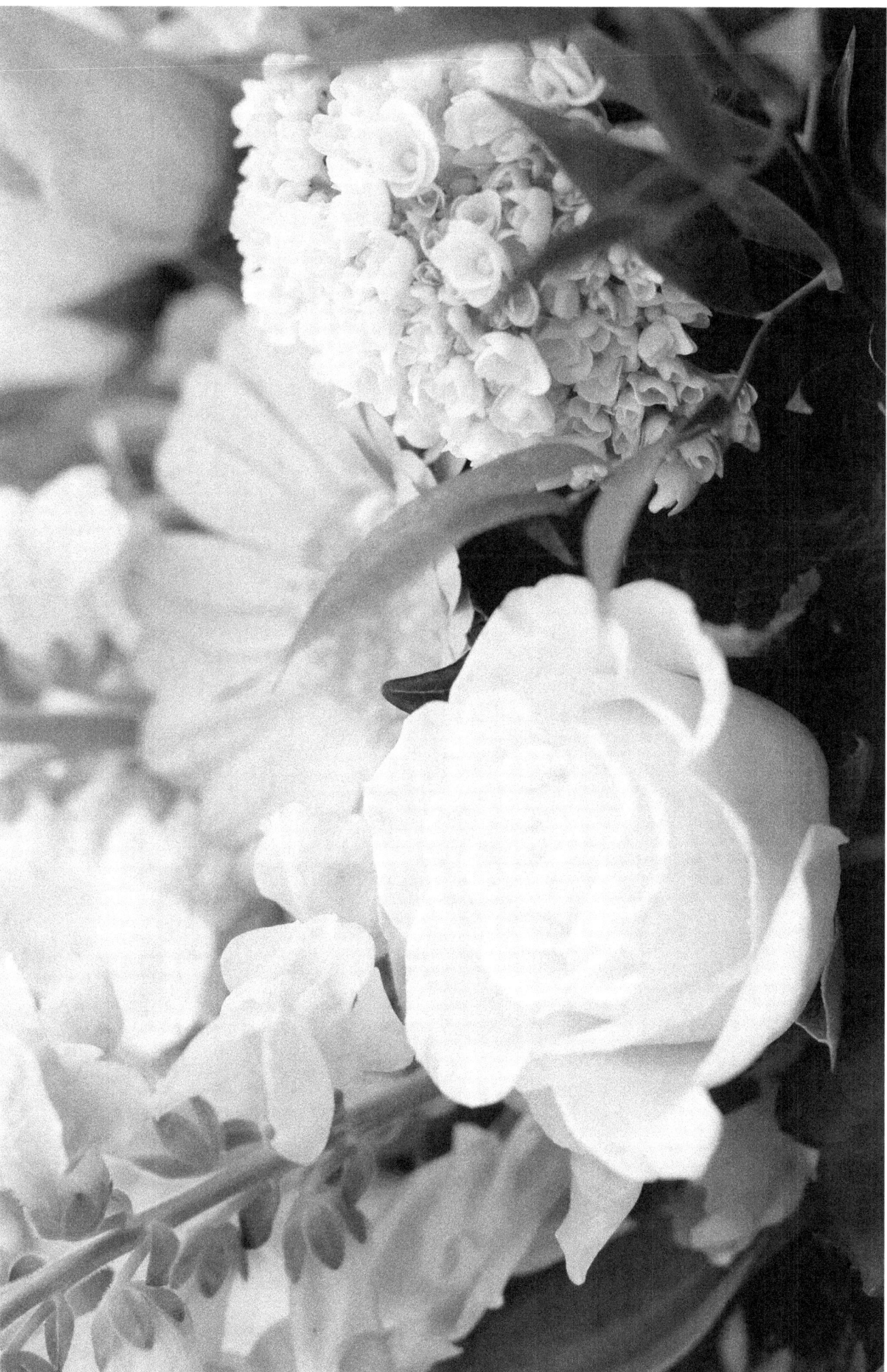

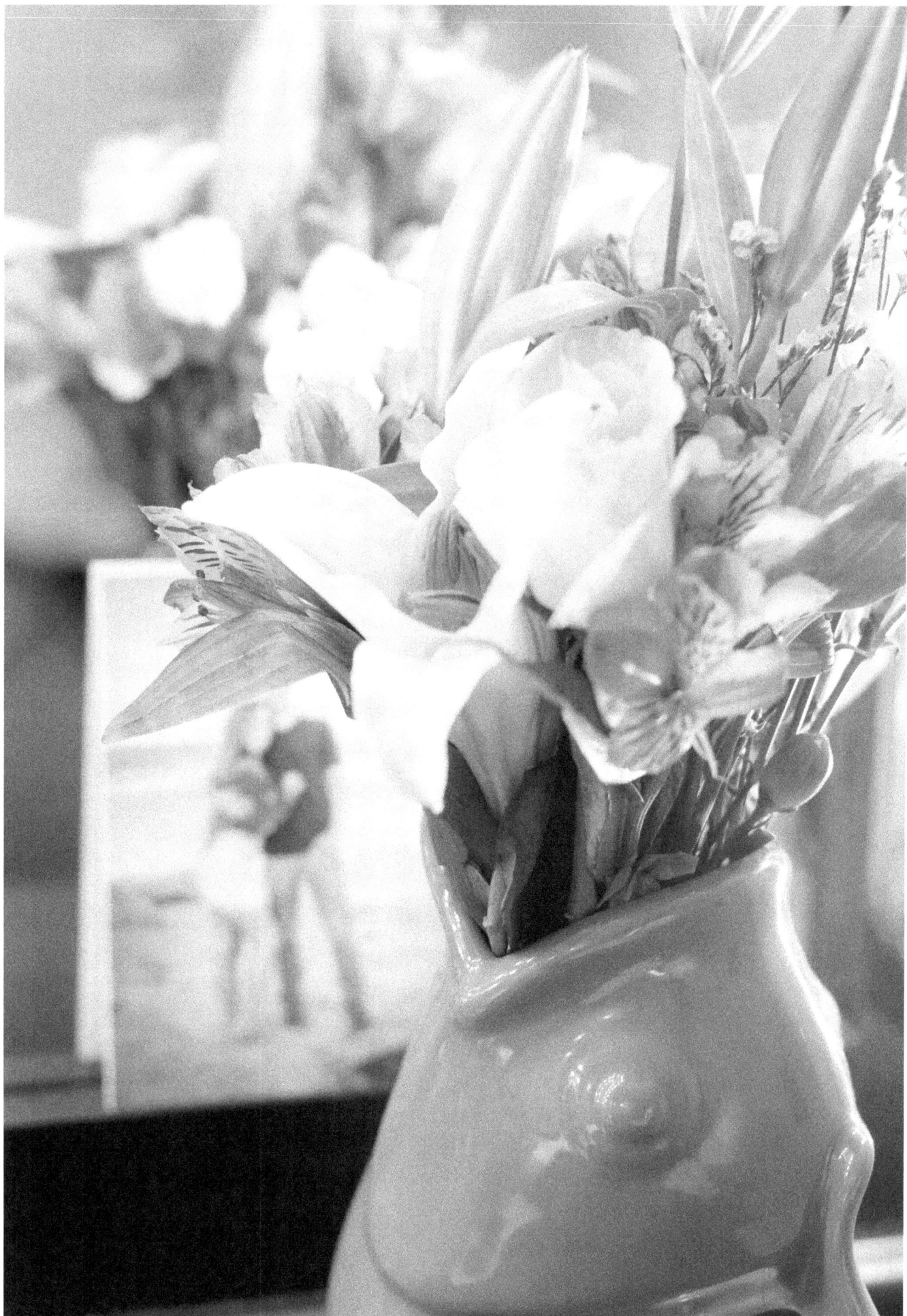

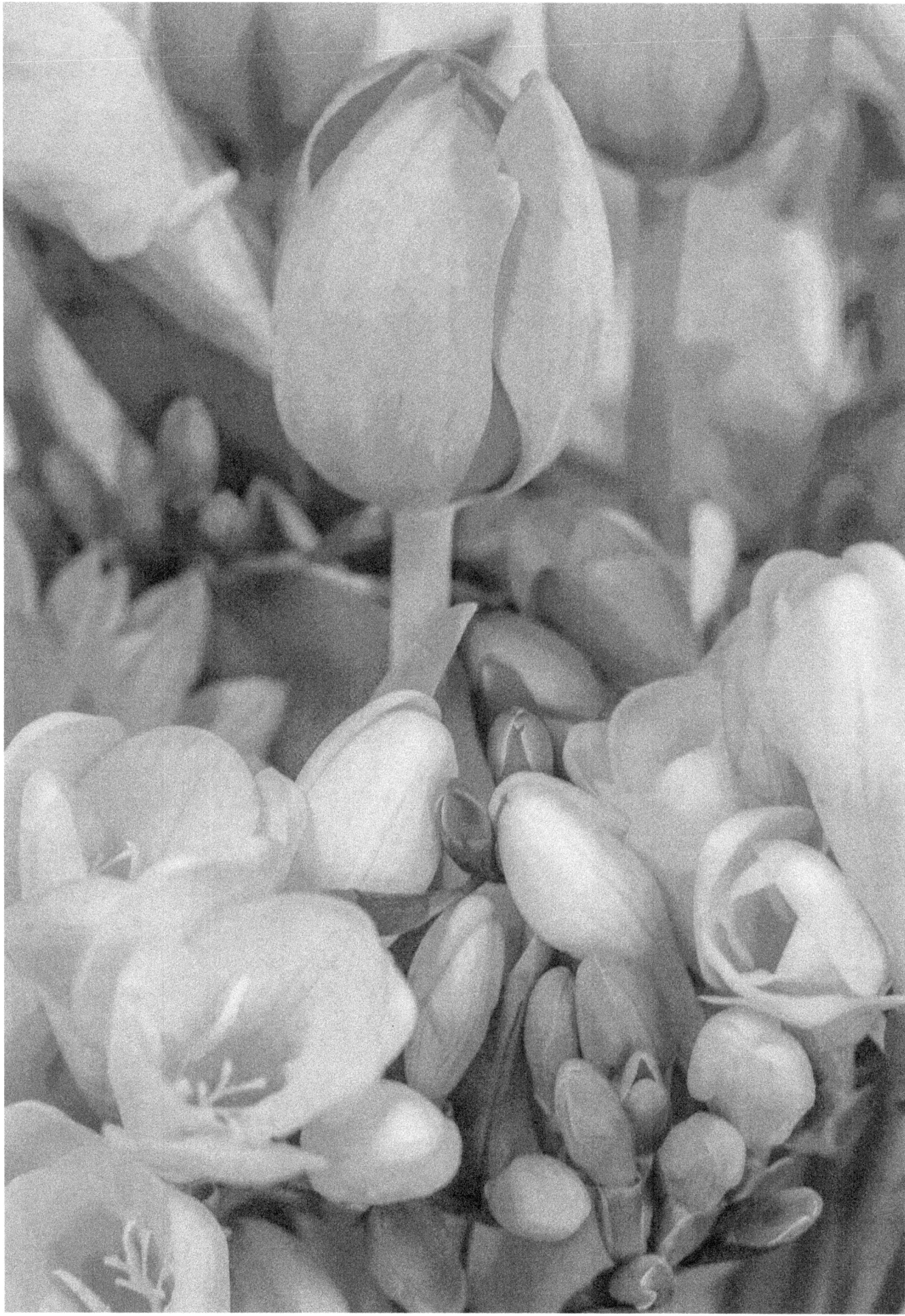

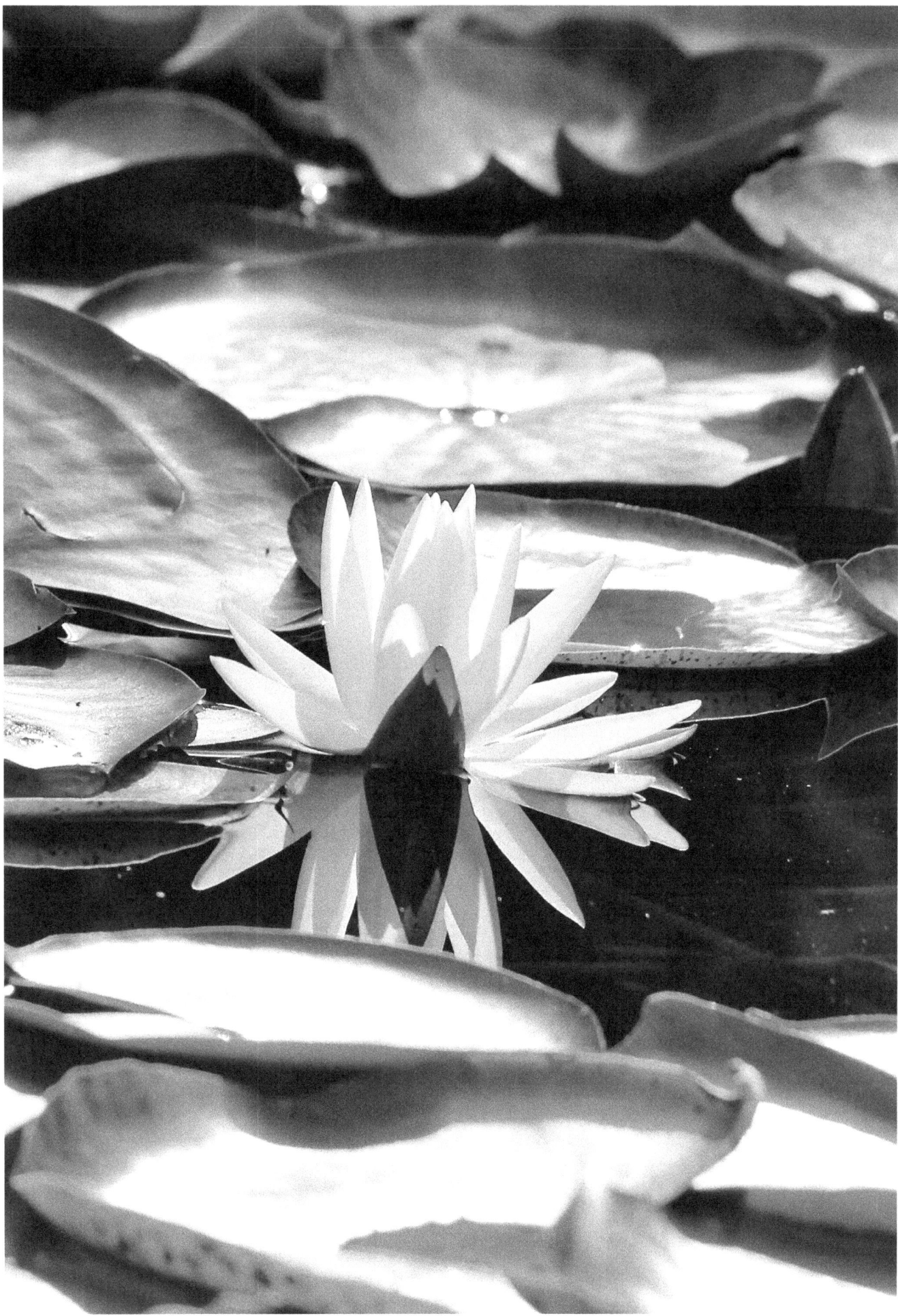

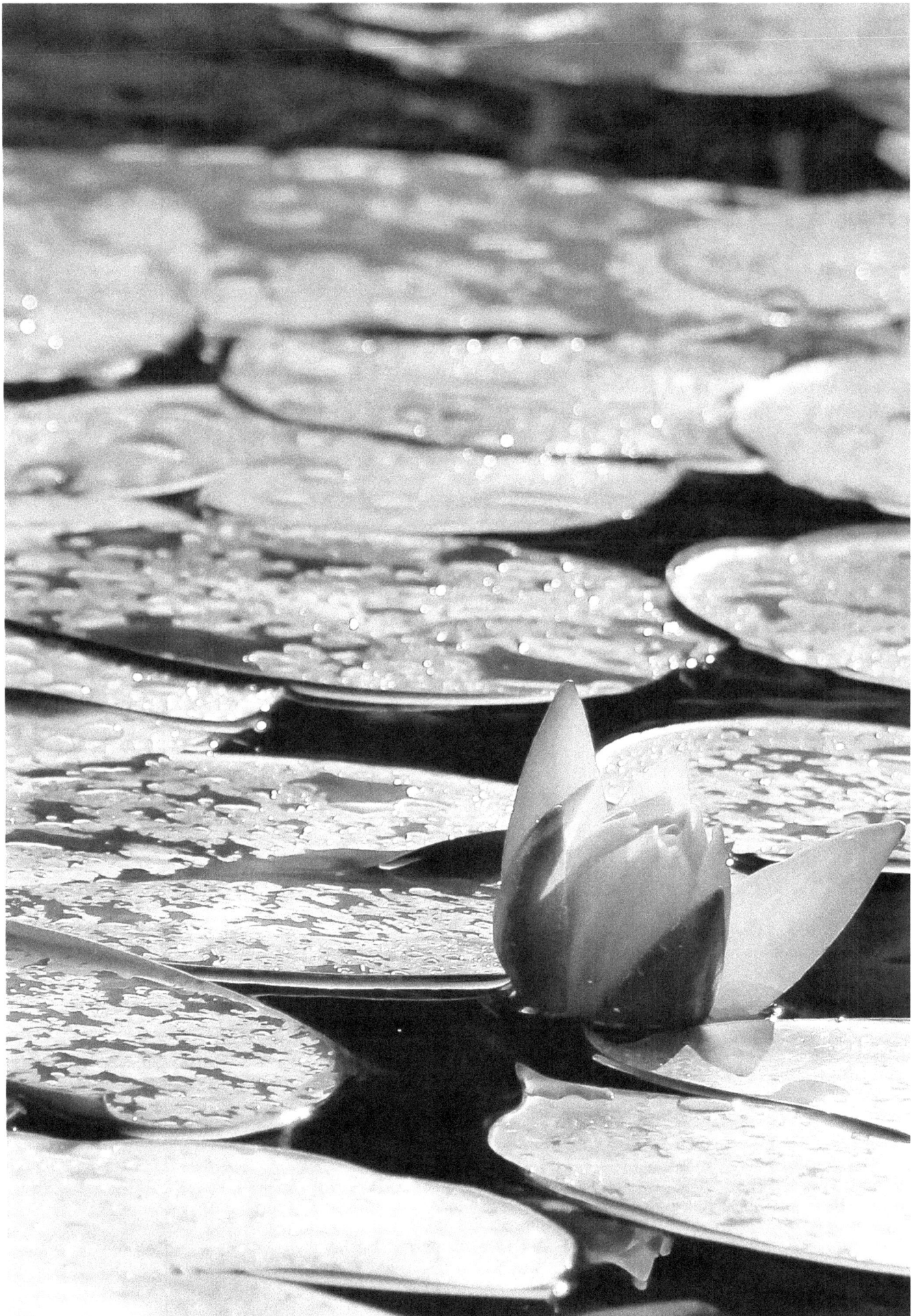

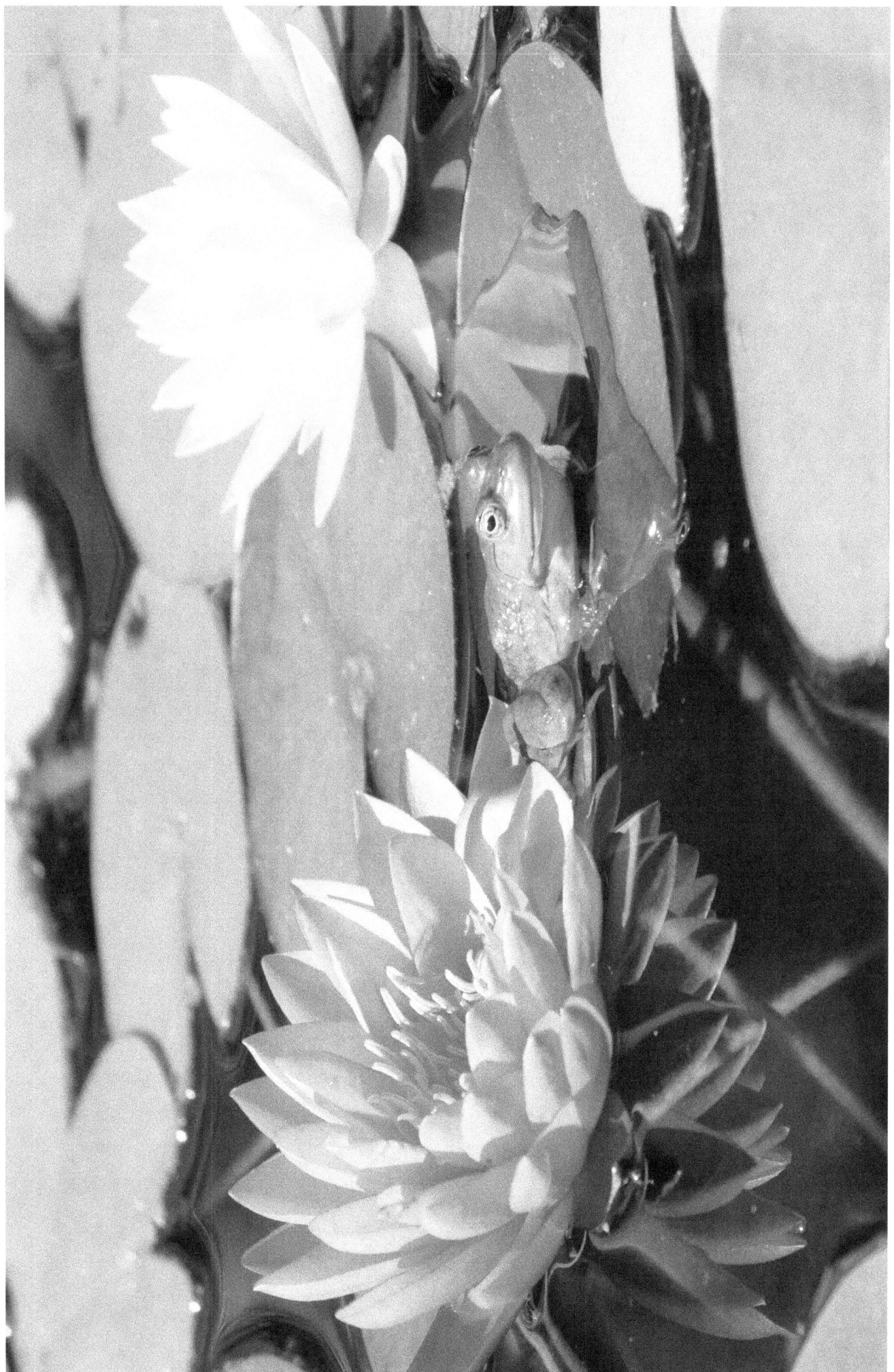

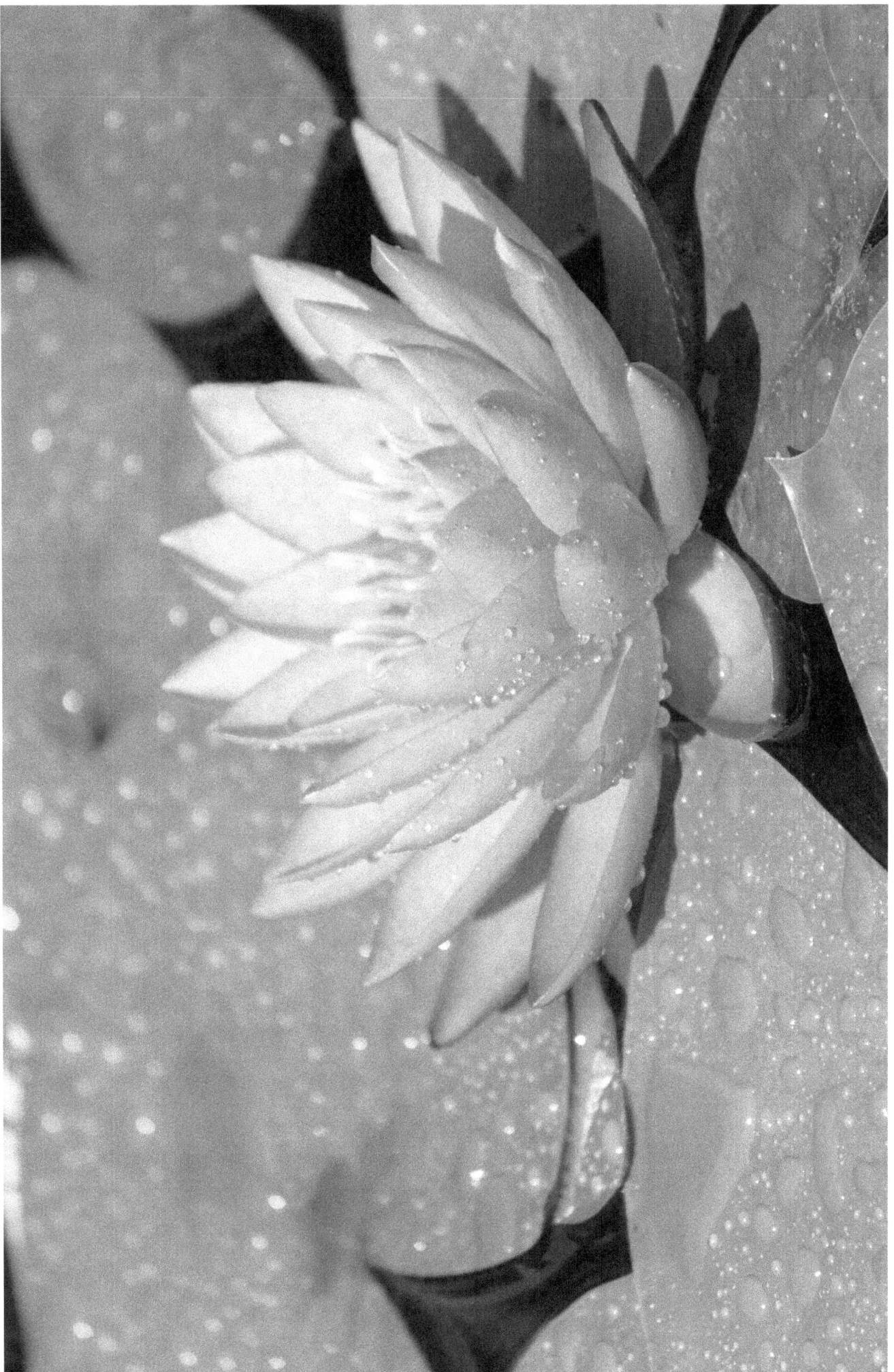

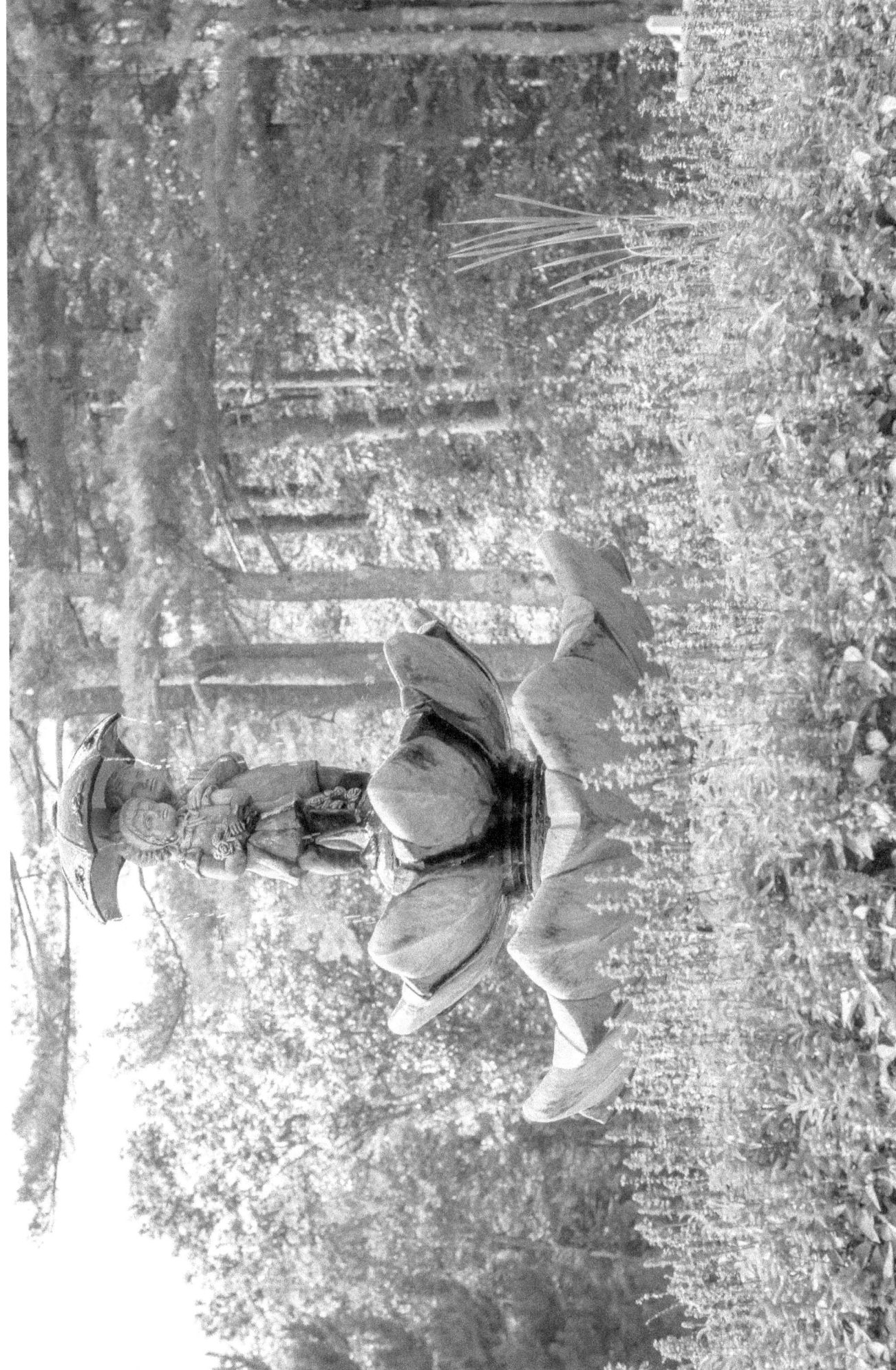

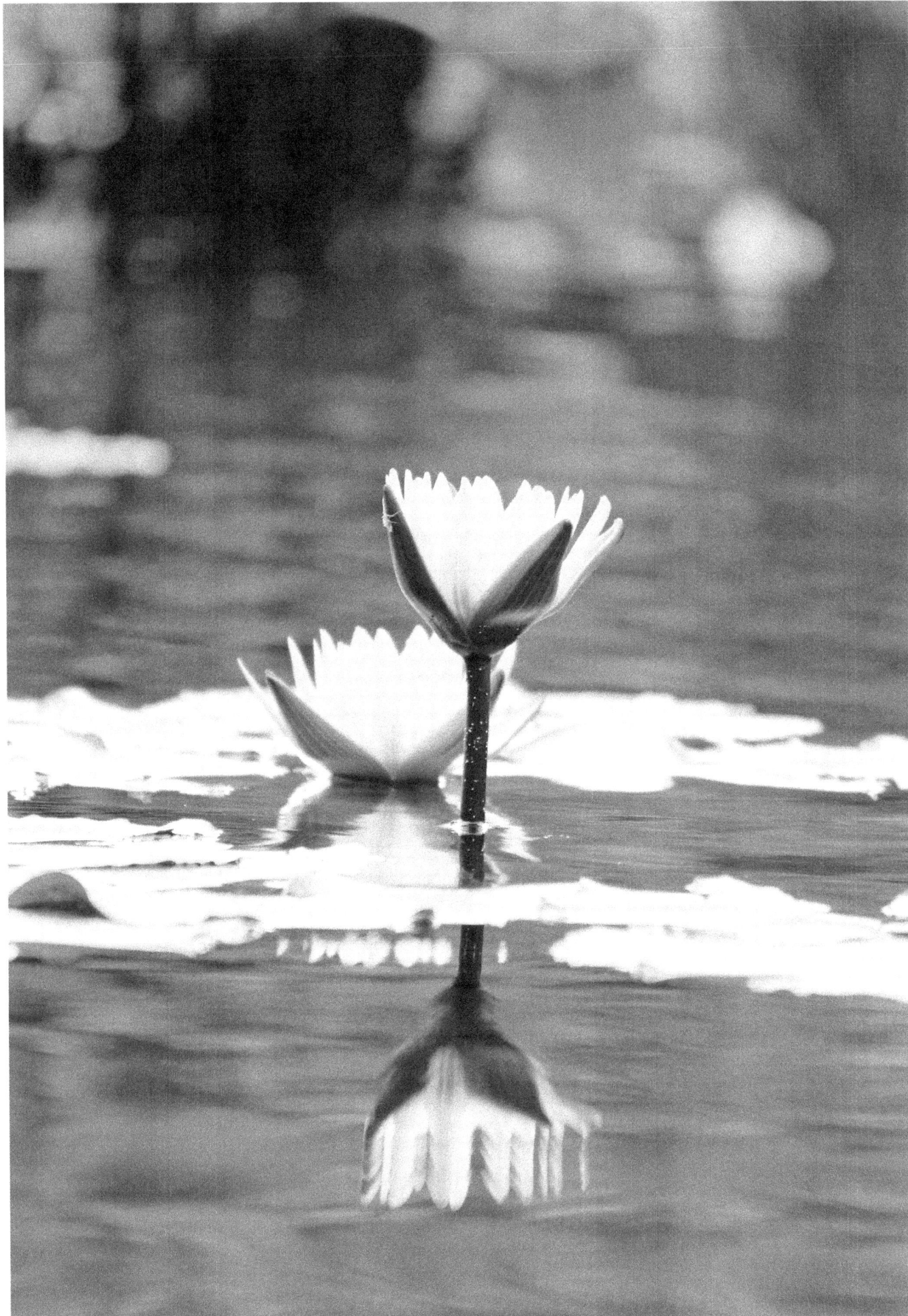

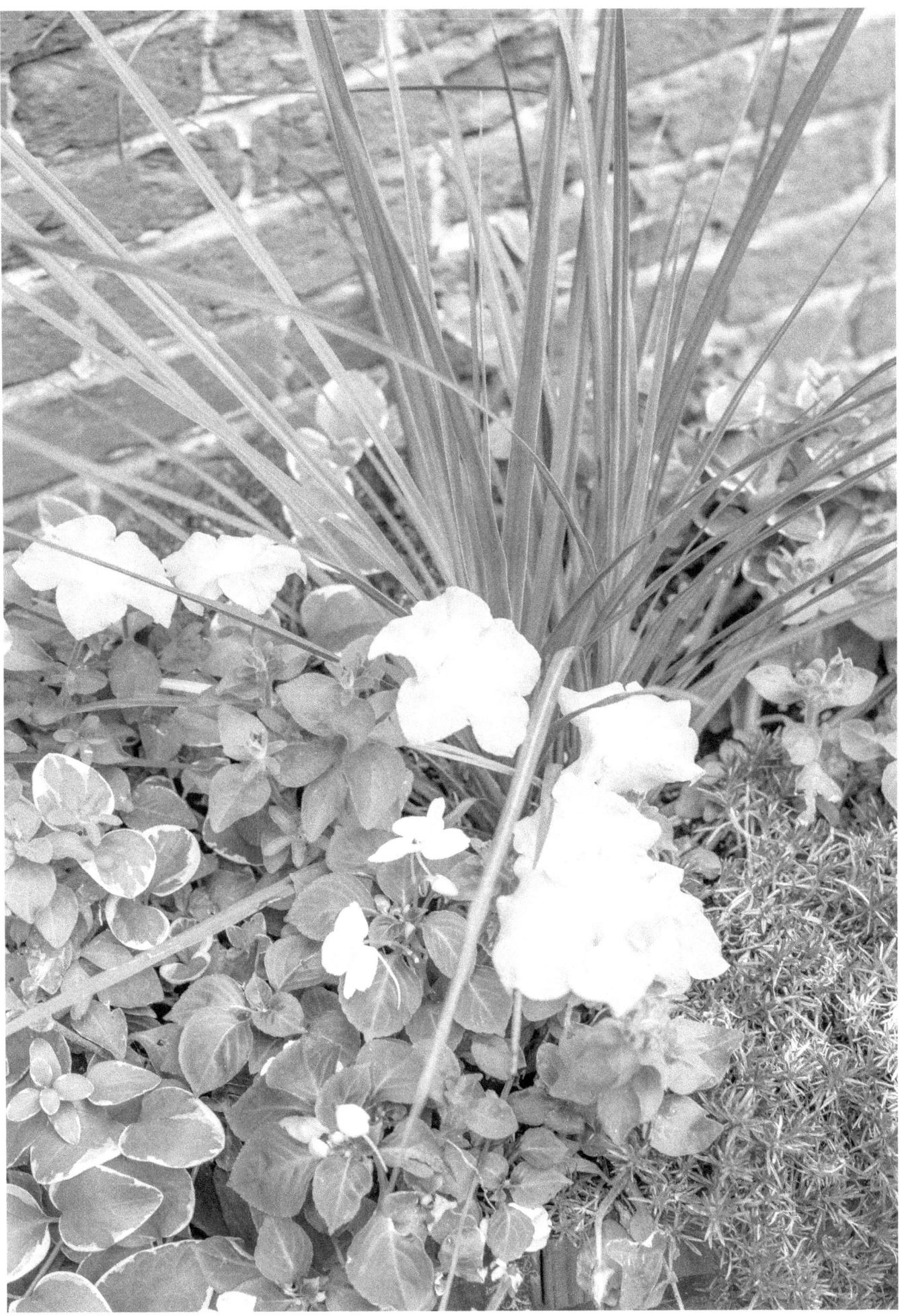

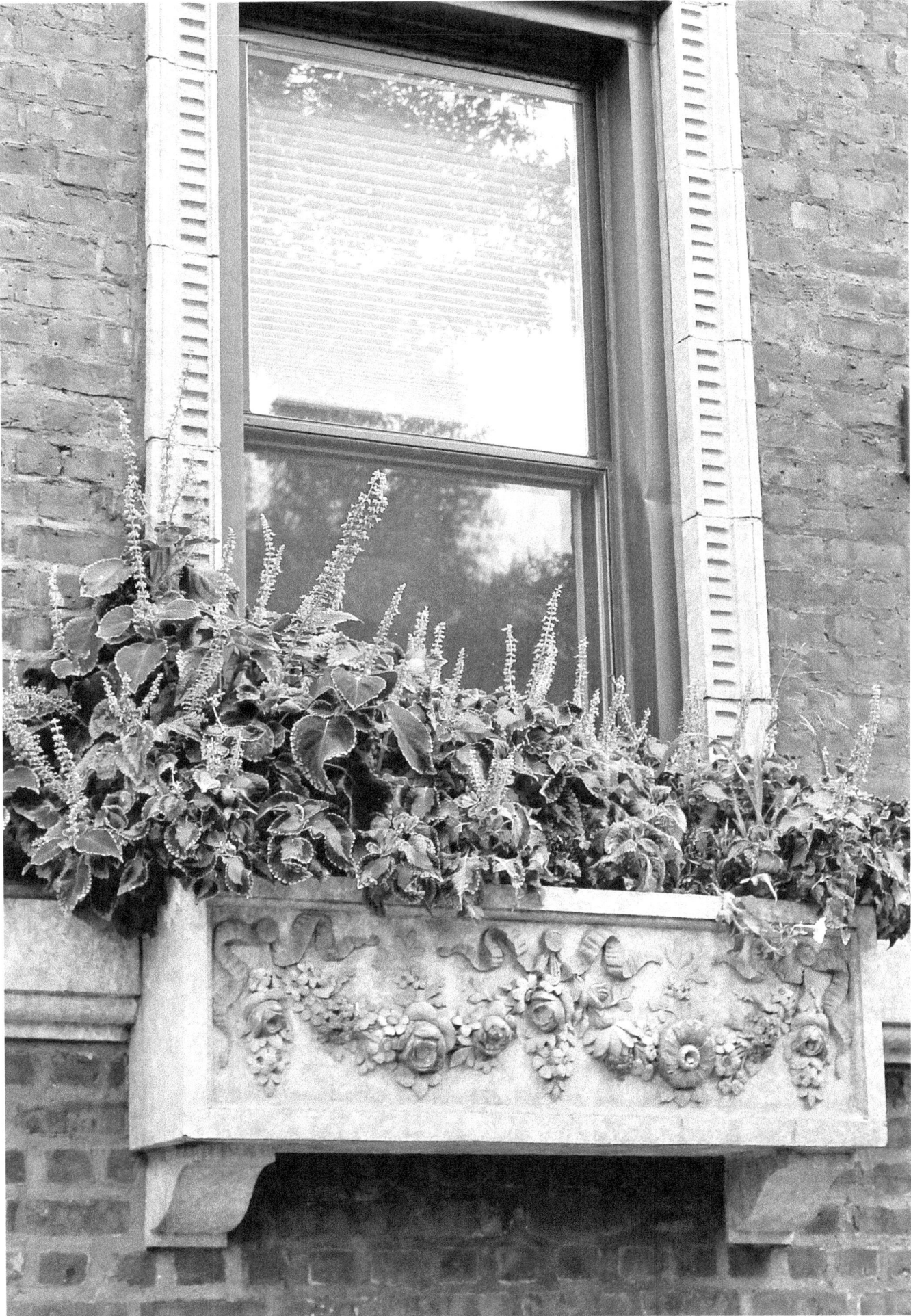

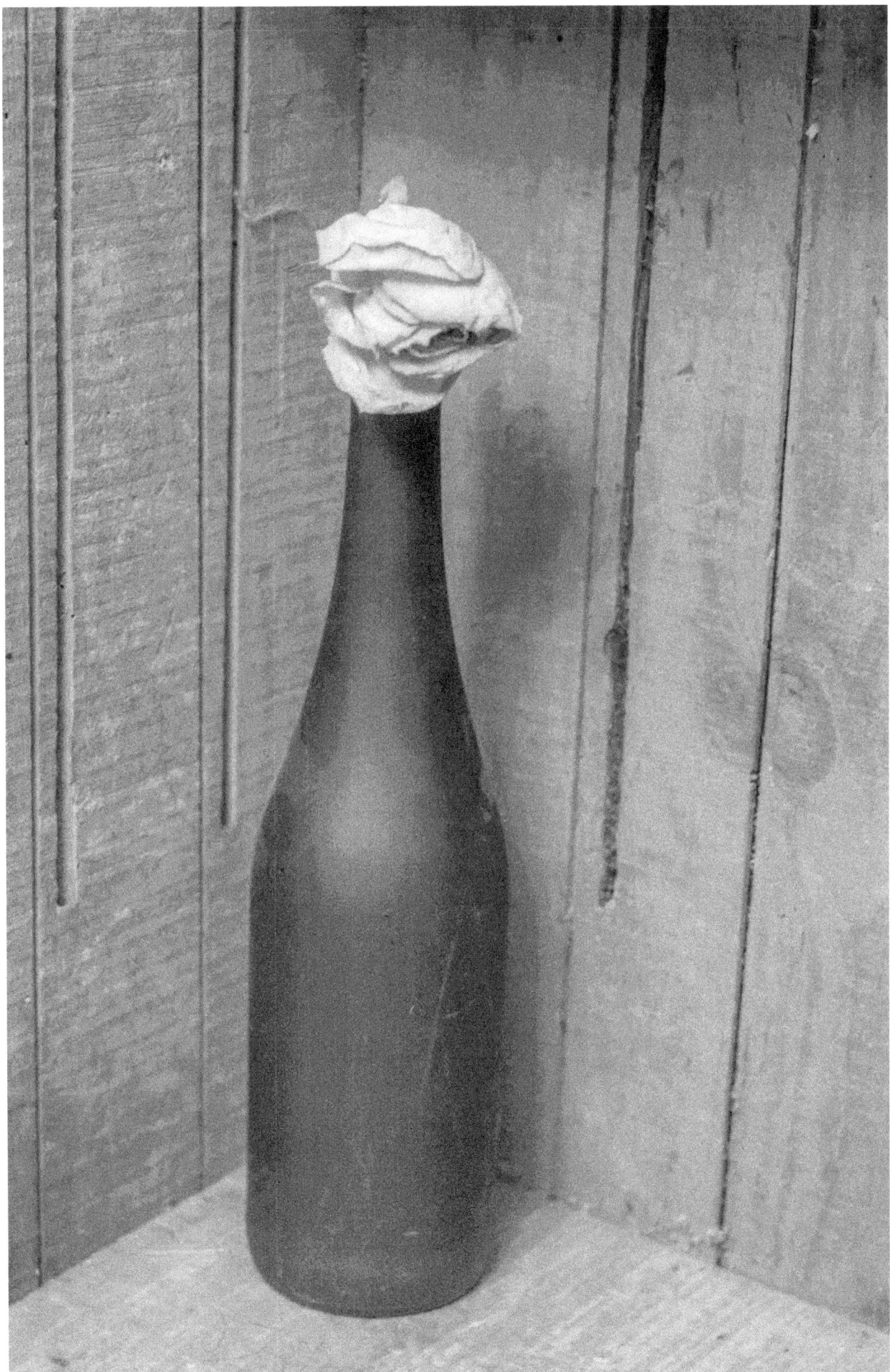

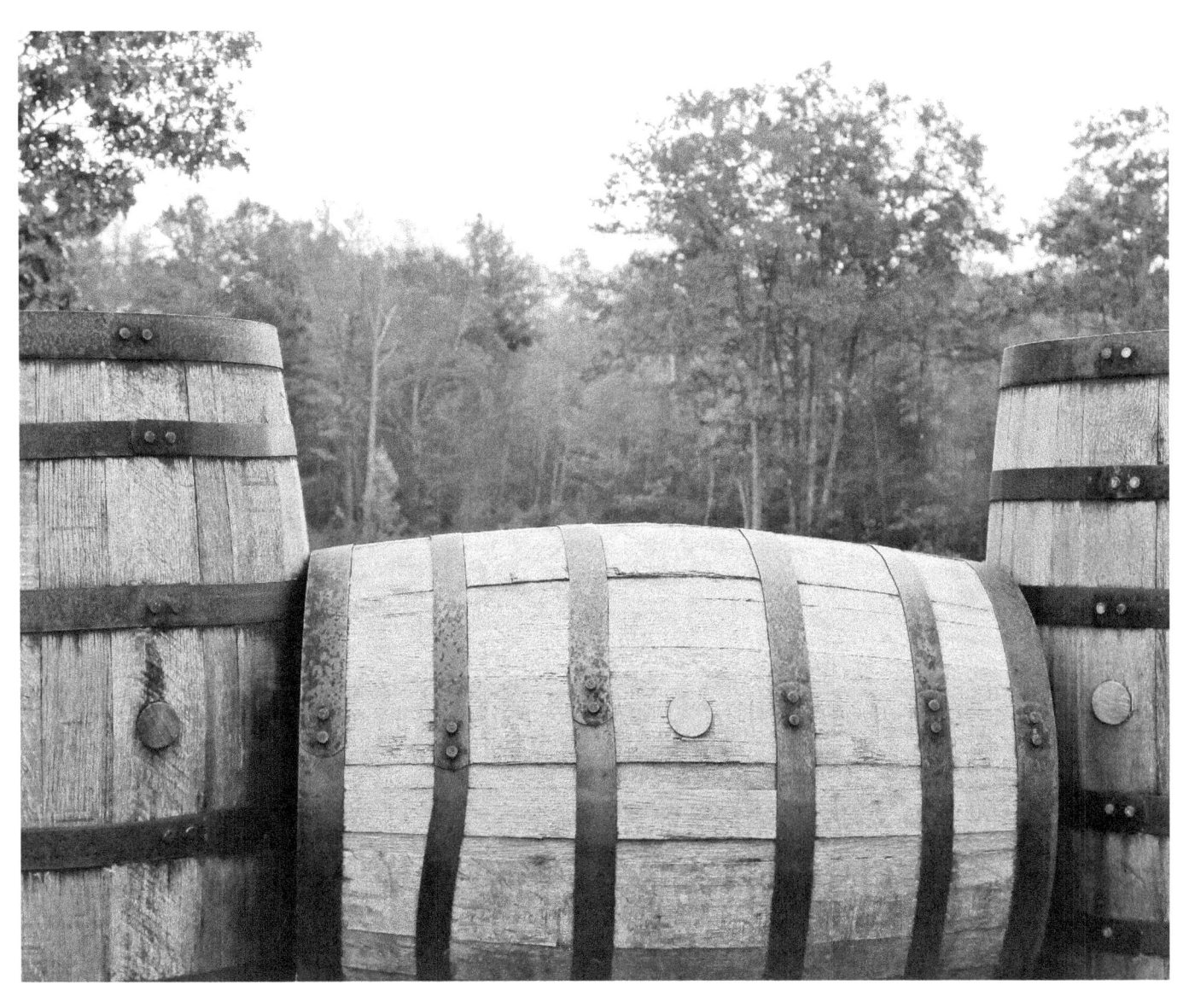

*A preview of my next book
Sunday Drive*